ISBN 978-0-6451525-1-7

General enquiries
Info@1000tales.org.au

Shop
www.1000tales.org.au

First Printed in 2020.
©Copyright 1000 Tales Co-op Ltd.

Editorial
Ameera Karimshah

Cover Design
Atiya Karimshah

Photgraphy
Atiya Karimshah
Ameera Karimshah
Shabnaaz Sheik
Pip Brennan
Michelle McGarvey
Chris Jordan
Kirsty Nash
Michael Connolly
Simin Contractor
Eevon Stott

We would like to acknowledge the Traditional Custodians of the continent of Australia. Whose cultures are among the oldest living cultures in human history and whose languages and knowledge have infused and inhabited this land for millennia.

We recognise their continuing connection to the land, waters and culture and we pay our respects to their Elders past, present and emerging.

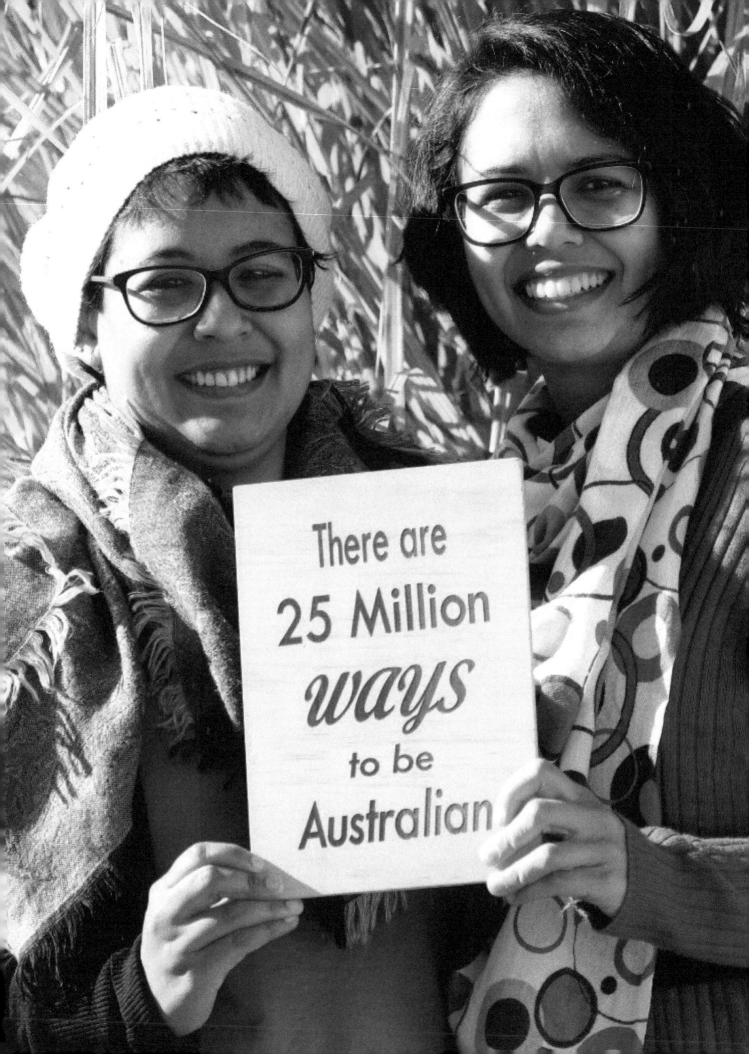

About this book

The #25millionau project came about as a result of an uncomfortable feeling we've had for almost our entire lives. When we don't see ourselves reflected back in our culture, when we are absent from our culture's representations of important things, who we are becomes insignificant. This feeling, while not originating in Australia, was greatly magnified by the stark contrast between the vastness of Australia's population and limited representation in mainstream media.

We arrived in Australia in our early teens. A world so distant and alien from the life we had known growing up in Zimbabwe. Knowing this was forever, we very quickly made this our home. We grew here, adapted, learned about our place in the world. We also learned to fit. You see, the impact of that uncomfortable feeling goes beyond our hearts and into our everyday lives, effectively limiting who we are and what we're able to do. We do this to ourselves, we begin to dismiss our own identities as unimportant for lack of an external narrative to contradict us.

We love Australia and have now spent more years proudly calling ourselves Australian than we did in our country of birth. We love the possibilities that we are presented with. The opportunities for freedom and education, for the ability to do whatever we allow ourselves to dream of but It's the dreaming that can be hard. We need role models that look like us. We need open conversations that speak to our fears. We need to know that our everyday lives are not peculiar, we need to hear other stories like our own.

'There are 25 Million Ways to be Australian' was born to counteract this feeling of being 'other' for ourselves and for others. We wanted to create something that fostered an understanding and appreciation of Australia's cultural diversity. As a nation we are made up of a multitude of histories, generations, stories and even contradictions that continually unfold and change shape over time. Our identity is deeply personal and its roots touch every continent on the planet. It can not be defined by stereotypes and we need to create recognition that who we are as a nation can not be portrayed by a singular image. The project combines photography and the personal narrative to highlight the richness and variety of our national identity.

We are made up of First Nations people, convicts, settlers, stowaways, migrants, refugees, every color and religion there is and so much more and yet this is rarely portrayed. Our aim is to record, preserve and protect as many of the individual moments, memories and journeys as we can. We view storytelling as an integral part of our global culture: to share knowledge; pass down traditions; entertain, and maintain a sense of identity. This project is about inclusiveness, respect and a sense of belonging for everyone.

Our vision is to see diversity become a part of our national identity...something to be celebrated! It started with a small photography setup in a shopping centre and before we knew it we were being invited into people's homes, histories, lives and cultures. We have loved fostering those meaningful connections and will continue to collect stories for this project indefinitely, we want to collect as many of those 25 Million stories as we possibly can.

We hope you enjoy reading them as much as we enjoyed collecting them.

Ameera and Atiya

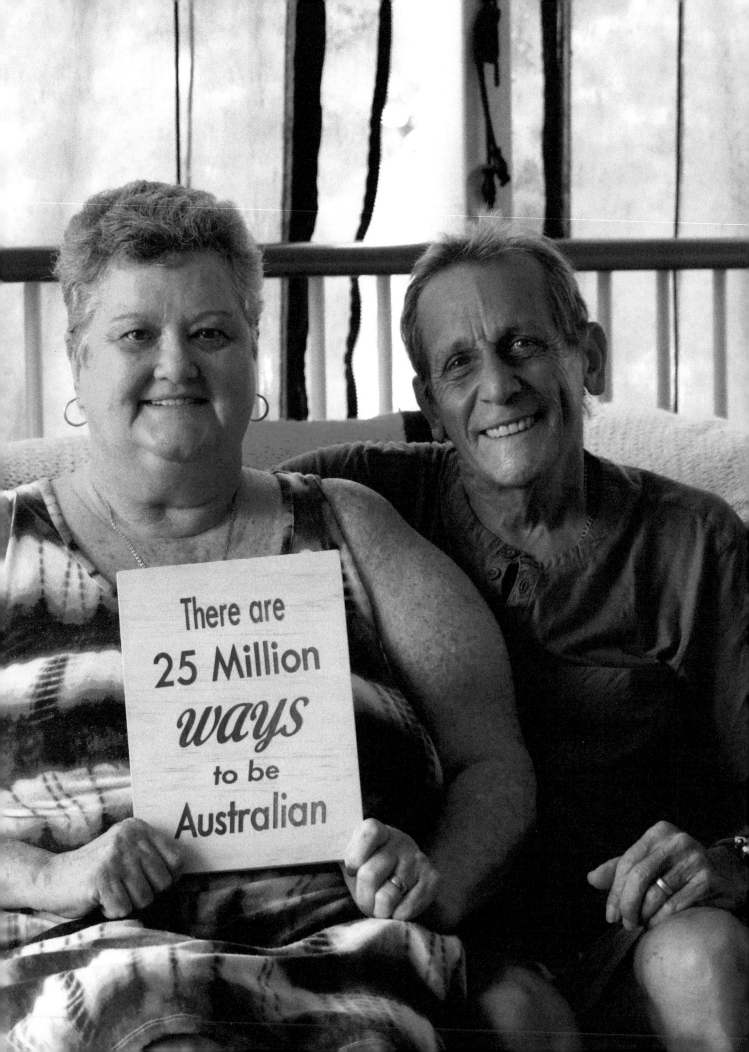

Uncle Bob and Auntie Vicky
(Robert and Vicky Butler)

asn't socially acceptable back in the 1940s and 50s for a white person to be married to an
riginal person. We were not even considered to be people. We were counted in the census
ng with the sheep and the dogs and the cats. We weren't accepted in the Australian community
ecame citizens until 1967. Up until then the government still had the right to steal our kids. They
 a right to dictate who we married, where we worked, what we did and how much we earned.
y had the right to dictate every ounce of an indigenous persons life up until 1967. A child would
o school in the morning and he wouldn't come home in the afternoon because a paddy-wag-
would have picked him up and taken him away and put him in a hostel or somewhere and that
ame commonly known as the stolen generation and a lot of families from all across Australia
bbed their older people and their younger people and they all took off from their traditional lands
fear of their kids being stolen.

ny people, not even people who were born here were even aware of that so it's imperative, I
pose for us to have new arrivals understand this. It's been a really difficult movement for all
riginal people which is why they get so paranoid about things and why they close up shop when
omes to talking about things because back in those days we were jailed for speaking our own
guage, all sorts of things, it was a nightmare and yet the early settlers were invited by us to settle
e cause that's the way that we were back then. We didn't invite them to come in and commit
nocide and all the other things that they did, they stole the language and the land and the kids
d stole our culture and stole everything and thats why a lot of people now are awfully protective
ut this. Some of them expect - I don't know if it's rightly or wrongly - I guess they expect every
er culture to look up to us because we are the first nation people here. And I guess the average
riginal or Torres Strait Island person struggles with non recognition I suppose and they get a
e jealous of other people when they get things because we should have it first and they're proba-
right in the way that they think about that. But now that the whole society and the world changes
've got to look at it a little bit differently you know.

e moved around a lot, my mother and father separated when I was about 3 and we moved around
ot. I found out later in life that it was because my mother was fearful of me being taken. We grew
one street from Musgrave park. I'd go across the park in the morning to go to school and there'd
Aboriginal people sitting there. Men dressed in white shirts and long trousers and hats, playing
aughts on a big concrete draught set in the ground. A lot of these people were related to me but I
s not allowed to talk to them or show them any recognition, because of the way society was and
r of being taken. These people were probably my aunties and uncles and cousins but I had no
ntact with my fathers family, or any of his culture up until I was probably in my early 20s. I always
ew that I was different from my two brothers, they aren't Indigenous and I knew I was odd. That
s really hard, in that I didn't understand why I would think about something differently to the way
ey would think about it or I would react differently to the way they would react to a situation. It
sn't till later that I discovered where my father was from and what my heritage was then things
arted to fall into place. By this time I had made numerous mistakes in my life and my marriage and
 sorts of things because I didn't know who I was. After that I've learned so much about the culture.
 still learning about things but I definitely look at things differently.

"When we have kookaburras come to your house or outside your house and calls, all afternoon or morning, somebody in the house is gonna have a baby and they come more often, closer the baby's time to being born.

Sometimes, they just come and sit on your fence or your clothes line and just sit there. It's the spirit of someone you've lost, you've got someone looking after you. That's the belief, that the spirits still looking after us."

- Uncle Bob (Robert Butler) - Aboriginal Elder

Uncle Bob (Robert Butler)

...ally had a funny experience one time. I was working up at a place called Kidston, ...hich is west of Cairns. It was the construction of a gold mine. From the airport to ...he mine sight, we were in a little mini bus to get over to our dorms and get our safety gear and hard hats and all that induction stuff that you do. I got this ...ally weird feeling come over me. All you could see was this flat land like in a red-y ...wn-y colour. Just flat earth with little bits of spinifex and a little bit of shrubbery on ...It looked pretty boring really but I made that driver stop that bus so I could jump ...ut and rub my feet in that dirt and I could not tell you why. I just couldn't tell you. ...got no idea why I did that but I realise this was part of the Aboriginal culture side ...ne. It's like recharging your battery. You get on home soil and rub your feet to get ...our connection. At the time I didn't know but that was the start of my learning to ...nderstand more of the Aboriginal culture and what it meant to the ancestors and ...hat it means now and what it means going forward so it was the start then for me to get my teeth into it and find out you know.

...e more I found out, the more I learned to appreciate that it is so simple. It is such ...simple beautiful culture. Why wouldn't you want to share it with people, because ...e culture in itself is really lovely. It's just a simple love - care for the land, care for ...he animals, care for the trees, care for other people - culture. And that's all it is.

...ou know in the olden times you'd only kill an animal if you needed to eat it. You ...wouldn't hunt for the pleasure. When another tribe comes into someone else's ...traditional land in the course of their hunting and travels they would announce ...hemselves first. Then the men and women of the traditional owners of the land ...ould go and greet these people. The women would take the women out, the men ...would take the other men over and show them all the traditional sites and the ...iritual sites in their land and sometimes they'd dance for days. Every dance told a ...ry, and they'd share these for days. So when these people moved on in their trav- ...s, they would go away and they would love this land like they would their own and ...eat this land like they would their own. That still applies because we still have the ...me thing for new people coming here. We still want them to learn and understand ...s. Many things have happened to us in the meantime which has made us probably ...ical, bitter or other things but the basis of the culture is still the same. And this we ...ant to try and help and promote. You know, so they're things that I think we've still ...ot to learn because in the early days both parties would share their thing and this ...what we've gotta do now. Both parties. New people that come here and us. We've gotta share these things. And that's the essence of how we all grow together.

Laura Lewis

My vision is to have a truly independent body with no bias and complete objectivity that has the powers to investigate abuse by staff and other students within Queensland educational institutions and keep our children safe.

I am actively doing advocacy work to stop bullying in our schools and drive awareness about autism. I also providing mentoring to autistic adults by assisting them into self employment among other things.

I am a proud mama to an autistic son, Clay. Clay was discriminated against repeatedly and unable to find a job so at just 16 years old he started his own business called Clay Needs no Molding. He now also employs 2 of his friends!

There are
25 Million
ways
to be
Australian

Helan Subhi

I was born and raised in Brisbane to refugee parents of a Kurdish background. I grew up with the best and wo
of both Kurdish and Australian cultures. Now I'm a social worker, giving back to the community.

I am interested in
reading, music, football,
playing the violin and beat
boxing. I aspire to become
a batsman in the future.

- Suhas Rangan. Age 12.

There are
25 Million
ways
to be
Australian

"I was raised as a christian girl and it wasn't until I was about 12 or 13 that I started to think, "not everyone has the same feelings as me about themselves."

Ash Polzin

I was raised as a christian girl and it wasn't until I was about 12 or 13 that I started to think, "not everyone has the same feelings as me about themselves." So when I was 12, I thought I was gay, and then when I was about 14 I was like oh I'm actually transgender, and it wasn't until I was sort of on the internet a bit more and found out that there were other people talking about their "non-binary identity" and I was like oh okay that describes what I'm feeling so I must be non binary. Which is basically just the concept that you know there are other genders apart from male and female. That was not received very well by my parents because that's not anything within their understanding of the world. And that's still a thing that causes conflict between us. We still talk to each other and everything but it's very much like; "lets just not talk about that part." They just choose to pretend that I'm still their daughter, so that's, not the best *laughs*. [it's made me] realise that a lot of people are homophobic or transphobic no because their a shit person, just because they don't understand.

What are the common misconceptions?

There is a big thing that you know, all gay people are pedophiles, which is not true at all. I've been told that you know, cause I've dated girls younger than me, "you must have corrupted them and like convinced them that their gay so you can date them." But they've been 'out' for longer than I have so that doesn't even make sense and also how would that work? Like I'm not a bad person. I wouldn't do that.

I think actually, a lot of people think that domestic violence can't happen in queer relationships for some reason and that's a big issue when you're trying to access help. If you are being abused and saying, "hey I'm in a violent relationship" and people saying "well you can't be because your partner is a woman" and so why would they do that? Or you know it's just rough housing like you know men are just like that.

People think that all trans people are trans women. And I think that's a bit of a stereotype in the media. That like every trans person is transitioning into a female...A man in a dress kind of thing. I was born female and now I'm not so....yeah I'm kinda like living proof that that's not true, and I know more trans men than I know trans women.

What are the biggest challenges?

It's really hard to access healthcare as a trans person, because there are a lot of people who just don't really understand how to provide health care for the population. So I started my own business in October [Phoenix training and consultancy] to provide that training and teach healthcare providers how to interact with the community.

We run 4 hour sessions for healthcare providers mostly mental health, just teaching them about things like; What does it mean to be part of the LGBTQI community? What are the barriers to accessing healthcare? What can we do to reduce those barriers? How can I, as a provider, provide the best healthcare for people who do identify? At the moment I'm working on some modules as well for domestic and family violence, alcohol and other drugs and family and relationships, cause those are some things that keep coming up. Like, I mean, with suicide, statistically between 45-55% of trans people have attempted suicide in their life. Anecdotally I would say it's closer to 90%. Almost every trans person I know has attempted at some point in their life. Which is pretty bad odds considering it's like 11% of the general population that have ever attempted. So anything we can do to reduce that to a more manageable level I think is really important. And one of those things is teaching people really basic stuff like respecting people's names and pronouns and asking questions about their identity and then actually respecting those answers. It's so important to provide a healthcare space that is accepting and welcoming and safe to stop these really horrible statistics from getting worse or staying the same.

For the most part the feedback has been really positive...that's the best part of my job like seeing people go from "I'd probably refer them to a different service that deals with this" and then at the end of it being like "oh yeah, I can actually deal with that myself" and not have to just keep passing the parcel kind of thing.

What does being Australian mean to you?

For me, it's not about where you're born or where you grew up or anything. It's more about participating in the community and being part of Australia. Being able to work with the community and know people around you, I think people who live here and care about living here, [are] really important.

I think by our nature queer people are very political people. Especially with the whole plebiscite thing a couple of years ago that really showed a lot of people, especially young people that it's important to get involved with this sort of thing. Cause I think when you are one of the groups that are directly targeted by conservative governments, I think you kind of have to be a bit political. It's hard to kind of avoid having a political view when your community is being targeted by people. It's hard and I think it's a thing that a lot marginalised or smaller, minority communities experience. You kind of get to the point where it's like okay, "You're attacking ME now" so this is not just a political thing, this is a personal safety thing.

Stasia Bayley

I believe being an inclusive society makes us all better Australians. I have four children, that are all grown up. Last year my youngest child began living life as his true self. He is transgender.

I believe a gender neutral environment won't convince kids they are transgender if they are not. But it would allow a transgender child to be themselves and to grow up feeling included and supported.

Being Australian means inclusion and diversity. I am a proud mum!

Gaya Ganthithasan

Lost place, lost identity.

Constantly on the move, that is the story of my life. I am a Tamil woman born in Eelam (Sri Lanka), a country where Tamils are still struggling for freedom - ever since 1949 when Sri Lanka got it's independence.

Even though my parents owned their house, we hardly lived in it. The years of constantly moving started when our house was burned down by the army. We moved so much I lost count of how many houses I lived in while I was at school. By the time I finished school, I attended eight schools in two countries.

When I was 17, my family moved to India as refugees. There I finished my schooling and got my university education. India gave me a scholarship to become a doctor but still, I was an outsider.

In 2007, I moved to Australia after getting married. One exam after another. One trial after another. I'm still not a doctor in Australia. Here, odds are against overseas doctors. Still hoping.

I am still hoping to find my place in this world, my home.

There are
25 Million
ways
to be
Australian

There are 25 million ways to be Australian...

Chris Jordan

"My dad was Yoguslav, born in Germany fleeing the civil war and my mu indigenous who was born in Merriwa New South wales."

Ho my name is Chris Jordan but your dad just calls me Cinnamon Myrtle.

an indigenous chef living in Brisbane, Queensland. I grew up along the Eastern Coast of Australia
d started working in kitchens from 16. I did my apprenticeship under Peter Kuravita at Flying Fish
staurant in Sydney and was lucky enough to work for Colin Fassnidge and Mark Best at FourFourteen
dney) and Pei Modern (Melbourne).

n a Koori man born in Maclean, New South Wales on traditional Bunjalung land on September 5th
39. My dad was Yoguslav, born in Germany fleeing the civil war and my mum, indigenous who was
n in Merriwa New South Wales. With a diverse cultural background of two cultures both facing
inction, it's important to carry this on in life and ensure it isn't forgotten.

oved to London at 21 and worked in corporate events and catering. My most recent work was at the
ana Pop Up in Sydney for Jock Zonfrillo.

you can see work has been a huge focus in my life.

en I was a child my father passed away. Three Little Birds was his favourite song, and inspired the
me behind my business. It started as a pop up event company in London. Hosting many quirky
ents throughout the UK including successful charity events for Macmillan Cancer, Roy Castle Lung
undation & Royal London Society For The Blind.

ce moving back to Australia Three Little Birds has become a way of preserving indigenous culture.
ing native ingredients, ancient knowledge of customs and techniques to make food that doesn't just
te good but also works to acknowledge, educate and celebrate the unique culture and natural re-
urces Australia has to offer.

r family grew up not knowing our Indigenous ancestry and it wasn't really something my mother or her
nily identified with, but I wanted that to end with me. Aunty Dale Chapman plays a huge role in my
ssion and knowledge with native Australian ingredients that is always growing. She is an indigenous
man born in Dirranbandi in South West Queensland on Yuwaalaraay and Kooma tribal lands and has
en my friend and mentor for years. I am constantly learning and I love sharing that growing knowledge
bush food with the world.

ree Little Birds is a catering business in Brisbane that specialises in native Australian ingredients. We
so host pop ups and events, our most recent event was Bush Food Feast at Woodford Folk Festival.
pical flavours on the Three Little Birds menu are: earthy, smoky and unusual. Dishes such as Native
lt Baked Sweet Potato and Orange Myrtle Carrots both charred on gidgee Coals, Mountain Pepper
iced Brownie. We hope to share our story through food, make our guests aware of indigenous cul-
e and fall in love with bush food.

stralia is a multi-cultural society, most Australians know more about Thai cuisine than they do about
tive ingredients. Being Australian to me is being proud of where you came from and sharing that with
e world. Understanding each other and connecting. I'm not proud of some of Australia's history but I
nk we're on our way to a better integrated and excepting society. I believe connecting with country
d the knowledge of our Elders will solve many of the environmental challenges we see today.

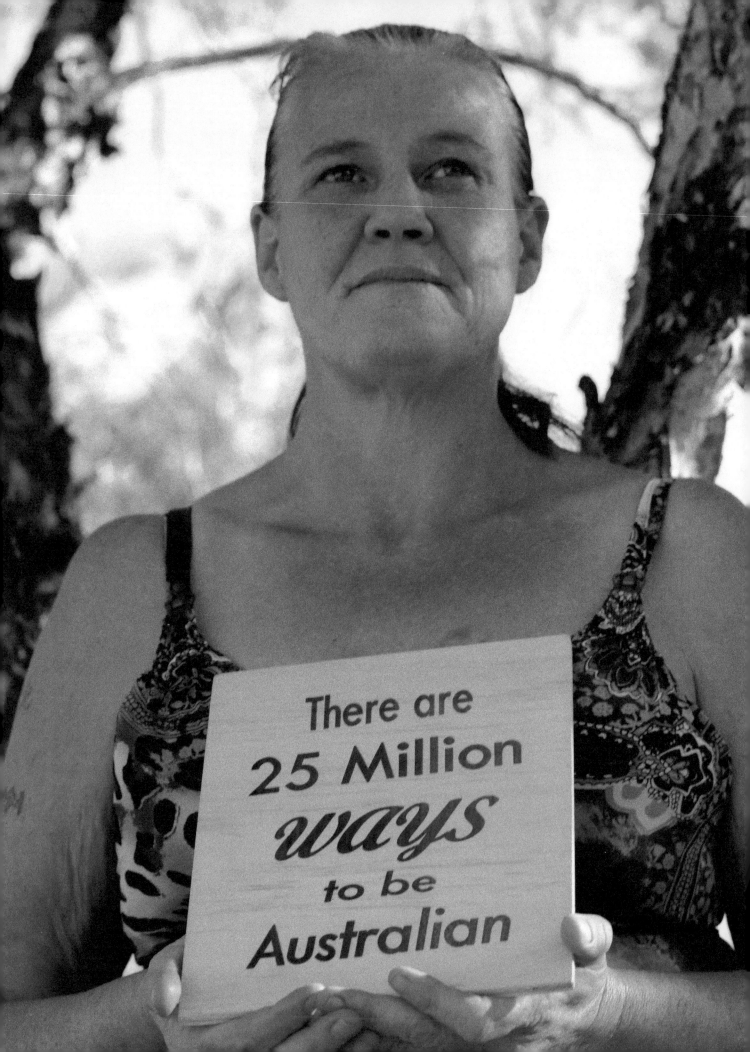

Sheena Douthie

was raised by my dad, so I get everything from my dad. He would
terally take his shirt off and give it to someone else, he started adopting
ids all over the place.

le would bring kids home with him. We had this boy, and it was my
rothers birthday and he got a transformer and Drew came over and
layed with Pete and when he went home the transformer left as well so
ad's like, "he bloody stole it, this little bugger."

Dad was a single dad, we didn't have mum. So he went round to Drew's
lace and the parents were doing drugs at the coffee table and dad just
valked straight in and went into Drew's room and he's like "hey, you
tole my boy's thing" and Drew had it sitting on a shoe box in the
orner and he was just sitting in front of it looking and his bed was a pile
f washing.

le had a pile of washing with a pillow on it, so that was his bed the poor
ttle fellow. So dad took him home. We still have Drew, 30 years later!
lis parents never came and got him. We lived in the same street. Their
roperty was 2 properties over. They knew that dad had him. Dad put
im through school.

le'd walk passed his parents in the shops and like they just didn't care.
hey never wanted him. How could you not buy your child a bed?

So that started dad adopting kids to the farm and we ended up with lots.
've had 11 foster kids myself because of dad. I just followed in his shoes
think. But with Samuel, I can't do the fostering anymore, it's just too
nard with him, he's just too out of sorts but we're still in contact with
ll the kids. I got Jessie when he was 14, Jessie's 26 now and he still
omes home for Christmas. His own mother lives in Southport in the
Gold Coast but he comes to us for Christmas.

The reason why we started Sharing The Love is because my big girl is 22 – She's just moved to Yarrabilba but she was here in Crestmead as well – But when they moved here they were really struggling. New baby, new job and everything and they needed help with food. I rang 19 places and no one delivered to Crestmead. Nineteen places for food help for her and nobody could help them.

So that's why I started Sharing The Love because there cant just be my baby girl out there. There's gotta be other people in Crestmead, its ridiculous so we first started it for Crestmead, like just this area here, and now we cover all Brisbane and Ipswich and some of the Gold Coast and it just went a lot bigger than I thought it would!

Our idea was to get donations of food and to cook meals and hand meals out when people do homeless drives. We supply the meals and that for them and it got a little bit bigger than that. So now we do new born packs and homeless hampers. The new born packs are pretty cool, you get everything from your baby bag to the bassinet, nappies, your hospital bag, everything,it's pretty good.

didn't expect it to grow like this. I really didn't and not so quickly either.

s good for Sam cause he gets to meet people and he gets to interact with eople. That's the only way he actually interacts with anybody, is if they me here for donations. So it's good in that way. Before he'd run and hide we had visitors and now he's quite open when we've got visitors. Very endly. Over friendly!

ut its good for him and Hayley, she was a very self absorbed teenager and she was forced to help me to start off with and then she became proud herself and people would thank her and she'd feel really weird about that. nen she just ran with it now she helps me with everything. Absolutely verything, she's amazing. But she doesn't tell anyone. Not a single one of er friends know. None of her teachers. Not even her partner knows. obody knows what she does. But yeah I think that kid is just brilliant.

am is autistic, he has a sensory disorder and auditory processing disorder. n not really sure what that one is yet. I find that he gets affected with his ars and wind and stuff and he's got behavioral issues and a evelopmental delay and ADHD and a sleep disorder. So yeah he's got a tle bit to deal with! Because it was hard to diagnose Sam, cause he's so erbal. Most autistic boys don't communicate, most of them are non-verbal.

o with Sam, with his social skills, it took 18 months to diagnose instead of e usual 6-8 months it took a long time so 19 therapy appointments, it was st ridiculous to start off with. We knew he was autistic but he's also 4 years d. You can't actually diagnose them until they're 4 years old. He got his iagnosis, a week before his birthday. With his ADHD, you can't actually iagnose that until their 6. So we know he is high functioning ADHD but we an't actually have that on paper until he is 6 years old , so when he starts chool. We need to get him ready for school. I don't want him to go, I want home school him. I don't want people picking on my baby.

There are
25 Million
ways
to be
Australian

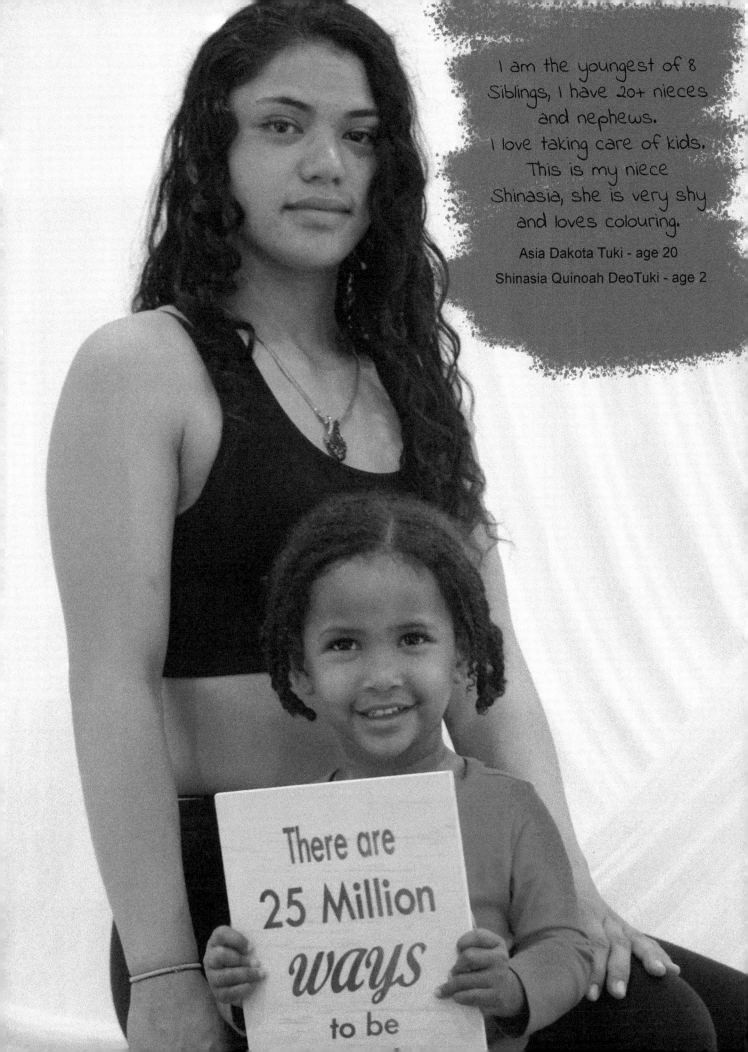

I am the youngest of 8 Siblings, I have 20+ nieces and nephews.
I love taking care of kids.
This is my niece Shinasia, she is very shy and loves colouring.

Asia Dakota Tuki - age 20
Shinasia Quinoah DeoTuki - age 2

There are
25 Million
ways
to be

Lucinda Phillips

There are 25 Million *ways* to be Australian

I think I'm 6th generation Australian on my mums side, not so many on my dads side. Mostly Irish and English on my dad's side. I grew up in Coburg, in Victoria and I went to high school, Moreland High School and I was the only one with Australian born parents in my class, which is kind of amazing but it was really good because it really gave me a insight into other cultures and languages. I could swear in like 10 different languages!

You know my best friend was Greek and my boyfriend was Turkish, I had Cambodian friends and Italian and Lebanese and it was just really a cool way to grow up so I think it helps with my just being accepting of everyone. I don't judge anyone on their skin colour of anything you know just try and accept people as they are you know.

My aunty moved up to Brisbane many, many years ago. We came up for expo in '88 which was kind of cool and I went back to Melbourne after a month cause my holidays ran out but my sister stayed up here and met her husband and so they got married and they were up here. So I was traveling back and forth and I got really sick in Melbourne and my doctor said I should move somewhere warmer.

So about 24 years ago I moved up here, with my boyfriend at the time and then we got pregnant like within a month or two, something in the water I think! So we stayed up here and that was fine, we've lived in Logan the whole time, It was the cheapest place to live to be honest!

My sister had bought a house up here so, we did. My partner and I we broke up after a couple of years and then I met my husband. Kind of a funny story, I was doing TAFE, doing community and human services cause I like working with people and a friend of mine was having a birthday party. So I went a long to help her out and I was early and a friend of hers from online - ICQ - had called her to say 'Happy Birthday', but she was busy so she goes 'Here talk to Ray," and I'm like "Okay."

We stayed friends after this and he called me later that night and back and forth, back and forth and three weeks later, cause he's in Melbourne, in Footscary, and three weeks later he says "look, I have to meet you!" and I'm like, "Aren't you engaged to a woman in America?" and he's like, "Yeah, but we've never met and I have to meet you before I go there." And I'm like, "Okay".

So he jumps on a bus and travels like 22 hours on the bus and by the time I meet him, I look at him and he is scruffy. He managed to get some alcohol from one of the shops and so he was drunk, he was scruffy, he had long hair! Hair longer than mine, didn't have a job, didn't have a life, I dunno, but he never went home!

A couple of months later I was pregnant again and we got married like 6 months later! So we've been married for like 19 years now. I know! If I had seen him in the street I would not have given him a second look, seriously, because he smoked and drank and he ugh, he was just so totally not a bloke I would ever date but there you go, can't judge a book by it's cover.

So he cleaned up his act obviously, he stopped drinking and smoking, he got a job and all that kinda stuff and we bought a house. We bought this house, 18 years ago. Yeah so we've lived around here. I don't drive you see, so we bought this because it was close to the school, I don't want to bus about and it didn't have stairs cause I'm classed as disabled now, arthritis and everything. I can't really walk very far or anything so yeah, that was good. So like I said, we've lived around here and just watched all the changes, all the new estates popping up and everything it's like amazing, yeah I love it!

I almost got my licence in Melbourne, right before we moved up here, I almost got my licence but I failed the test and then we moved up here and then I got pregnant straight away. I was quite a bit bigger, if you can imagine that, I was like 50 kilos heavier, I was really big and I couldn't reach the peddles, because I had to have the seat right back to have the seat belt on, but then I couldn't reach the peddles. Then, I was pregnant and I just never got round to it to be completely honest.

Now I probably could go but my husband drives. He takes me anywhere I want to go and my kids drive and there's the bus, so I guess there's no pressing need for it to be honest. Now that I can reach the peddles and that I could probably do it but I'm like meh!

For a while there I was quite agoraphobic, I didn't leave the house. I went through this stage where I just, I couldn't leave the house. It was terrible, and I had a friend who would like pick me up and take me down to the school and got me involved in the P&C, so she'd get me out but I was never really very comfortable, cause you know I was like, "I have to do this" but yeah, after my kids finished primary school I was like nup! I don't need to do that anymore!

So, I stayed home and then my mum got really sick and my mum lived in Melbourne. She got really sick with Lymphoma, and so I just had to put on my big girl panties and suck it up and fly down, I don't like flying. I don't like being trapped in a space that I can't get out of. So I don't like flying, but I suck it up for 2 hours cause I just had to. I put my headphones on and just focus on music basically. She died Christmas day 2013 and my aunty who lived up here and I, we'd booked to go down on Boxing Day, so we just missed her. I should have gone down a week earlier, that's my biggest regret. I don't have a lot of regrets in my life, but my biggest regret is that I didn't go down a week earlier, you know. I was down there for a month at the start of all this. All through September, I was down there, and you know, I just had to suck it up you know and I got over this agoraphobic thing. It was all in my head obviously and I just had to get over it so I did. I still don't like crowded places. I don't go to concerts and things like that, I don't like shopping centres particularly, I don't like them. In school holidays, I avoid them like the plague! The noise gets to me, the noise level, it's like finger nails on a chalk board, I'm just like, ugh! So in and out, if I have to go. Yeah but no, shopping and I mean I can't really walk all that much, so shopping is not particularly fun and yeah I shop online. Thank God for the internet. I swear to God, if I didn't have the internet, I would be a hermit, stuck with no friends! A lot of my social interaction is on Facebook, you know, and I get out and meet friends now, which is good.

I'm in a group called, Book Crossing. It's basically a website where you get a sticker with an individual ID number on it. You put it in the book and then you release your books everywhere, where ever you like and when people pick up these books, on trains or where ever they find it, they can go on the website and journal it so you can see where these books are traveling. I've had books that have traveled all over the world. It's wonderful! Yeah I joined about 15 years ago and there's a Brisbane group that gets together once a month and my friend Peter who lives in Canberra, he was the first book crosser I ever met, cause he came, he was up here on holiday and he came to my house with a box of books and said "pick a book" and I took one and he said "no, take more! take as many as you like" and I'm like really? and he said "yeah!" So I did. And he was up this weekend which was nice after 15 years to catch up again.

So I've always loved books. Always Always! I didn't have a very good childhood and my parents being married and divorced and dad had gotten divorced for the second time by the time I was 12 and I lived with him. For some reason my mum didn't get us in the first divorce, they went to court, there was a whole big thing, it doesn't really matter but my dad got custody of my sister and I, then he remarried and anyway!

books were my escape and I read a lot and my Poppy used to go up to the library and check
20 books. My dad, my Poppy and I we'd all just read and whatever he got that's what I'd read.
s of SciFi. Then when I got old enough to get my own library card, I got my own books. Still
of SciFi but more fantasy and SciFi. Always loved reading, always had lots of books and
rything.

kids are grown up now, my baby turns 19 in October and she moved out a couple of months
and I cleaned out her room. And she's like, "I've got all these kids books mum." I'm like, "am
tting any grandchildren anytime soon?" and she's like "nooooo!!" She's in a relationship with
erson who is transgender, so transitioning from female to male. So there's not going to be any
dren there. I'm kinda glad, cause like i said, she's only 18 and too young to get pregnant and
rything so thank goodness!

So I had all these books and I was reading,
online, about these free libraries and I've been
meaning to do it for a couple of years and it just
sort of came up right when I decided to do it. I
found these cabinets on Facebook marketplace
and I'm like, it's a sign! So I got them and put them
all together and yeah my daughter decorated it all
for me, better than I would. I'm not very creative,
no artistic ability whatsoever, so yeah, that's how it
started.

It's nice seeing books go and come back. It's not
so nice when you see some of the books for sale
on marketplace. So I've had to start writing on
each book now which I hate doing. I hate
de-facing books but I don't think it's right for
people to take it and then sell it. I don't mind
people taking them and being like oh I love this
book so I want to keep it. No worries. But to sell it.
That's just, it goes against everything I believe in
with books.

free for everyone to share. I love it. I
e seeing kids find a book that's spe-
l to them. You know I've been out a
times, talking to the people and say-
you know, come on have a look! And
ey are sort of like, "are you sure?" and
like "Yeah! it's free, take a book, you
ow. Keep it if you want. Bring it back,
if you've got any spare that you don't
nt bring it back, that's fine." A few
ople have. A few people have been
tting books in and taking books out.
ah. It doesn't take much to make me
ppy really and that makes me happy.

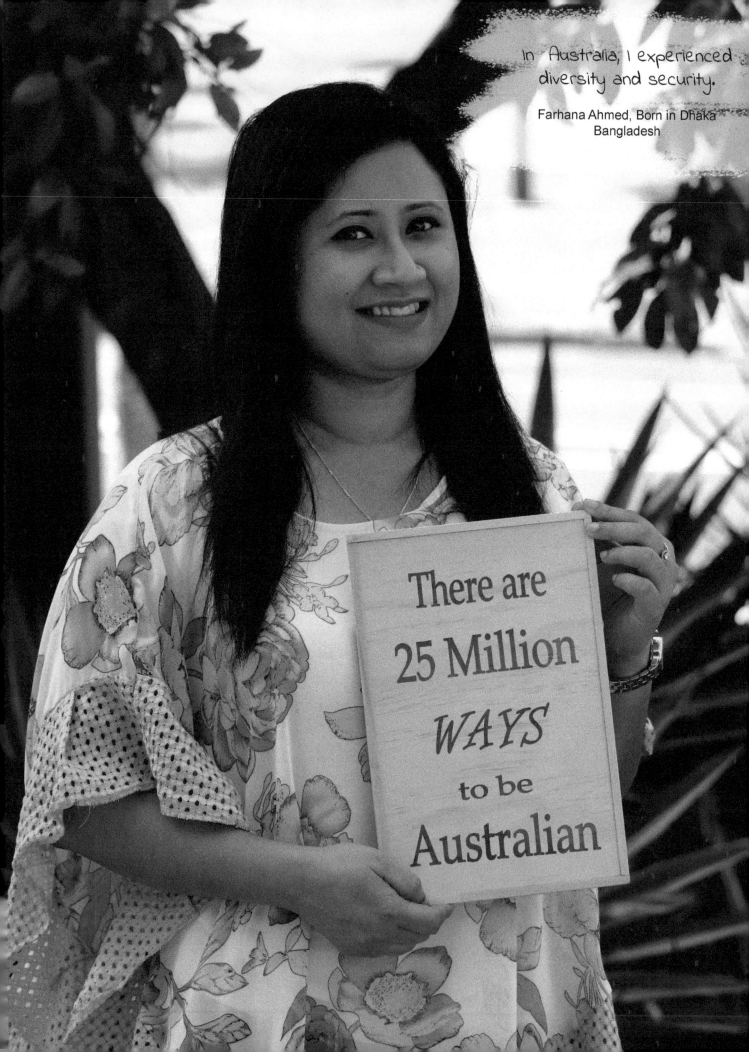

In Australia, I experienced diversity and security.

Farhana Ahmed, Born in Dhaka Bangladesh

There are 25 Million *WAYS* to be Australian

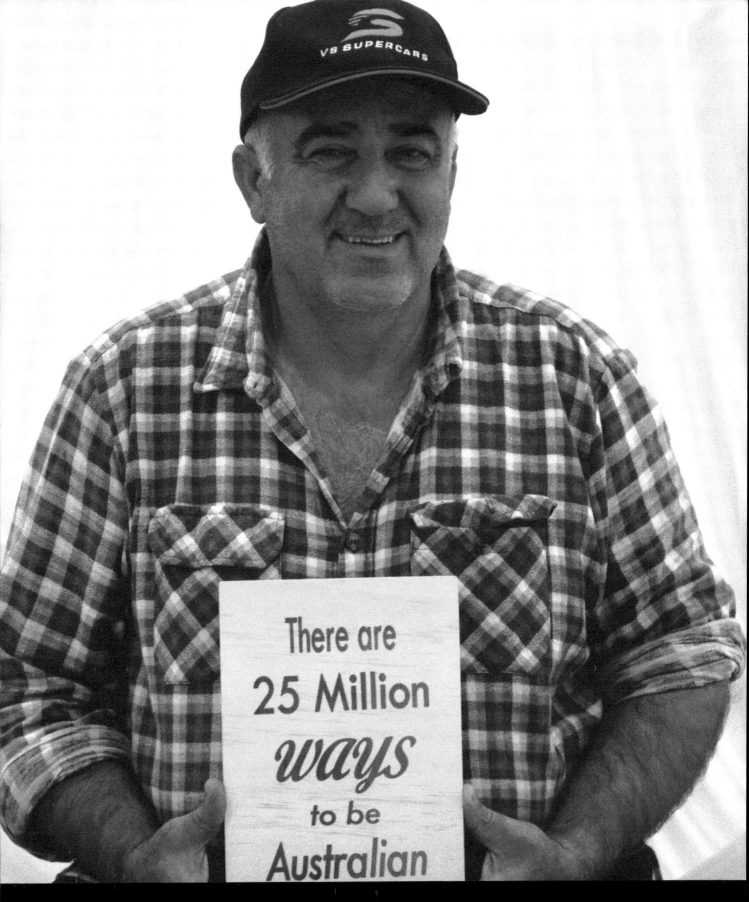

There are
25 Million
ways
to be
Australian

Osman Somboli

am Kurdish. I left to escape the war. I have been in Australia 26 years.
n trying to bring my four brothers to Australia. I haven't seen them for 40

There are
25 Million
ways to be
Australian

Simin Contractor

am a Graphic designer by education, who turned to textile art and design when I nished university in India (National Institute of Design, Ahmedabad). I come from long line of family that have been in the creative field so it was only natural for ne to move in that direction. What I really wanted to be when I was young was a eterinary Surgeon. I am also a Level 2 trained yoga teacher.

Having grown up in the textile capital of India, it becomes a part of who you are nd how you perceive handicrafts and textiles. I felt that traditional methods of rinting and mass producing scarves couldn't add the uniqueness and character hat people deserve to wear. I wanted to create an individual scarf, when worn nakes you feel unique and special. The solution was to take inspiration from the ncient art form of silk painting and paint unique creations directly on the silk anvas, only this time to be worn instead of being hung in a museum.

he creative process, from inspiration to the finished product is what keeps me oing, and of course, there's nothing like running your own business even though comes with its own set of challenges.

My business is an online store that sells hand painted silk scarves with select tockists around Australia. Each scarf is individually painted making them unique. pride myself in supporting other women in business for example. My silk dyes ome from NSW that are home crafted by Silksational. As of now I am the only ne who designs, paints and manages the business with immense support from ny husband (a huge asset with all the IT help needed) and my twin teenage girls who help with social media, video filming, editing and photo shoots).

My connection with Australia goes back 20 years! When I decided to start painting n silk, the only country I could source my dyes from for a good rate was Australia. And it helped that I had family here so shipping was taken care of. I noved to Australia almost 18 years ago and now this is home. I am particularly roud to be an Australian today My true stamp as an 'Aussie' artist got validated when I was selected by the Uncovered programme hosted by the Sydney Opera House. To have my silk scarves on sale in their stores is a true honour.

Brian Rhodes

Greetings and salutations to all my fellow crew and technicians of spaceship earth. My name is Brian Rhodes I am the poet4eternity, I am the pan dimensional bard, I am an ancient alien, I am a master alchemist and I am a writer of genius quality, working on two works, one a magnum opus on alchemy, that when finished will cover around 6,000 to 7,000 pages, and an ongoing work on and about the Merlin energy. I am currently residing in the Southern hemisphere, on the magnificent continent of Australia, of the beautiful planet earth - this blue green gem sitting in the unique eternities of space and time - but rather than being an Australian I am an earthling with all the rights and privileges of said birthright. I was conceived around Christmas day in 1957, and I was born roughly eight months later, on the 14 of August 1958. My parents were married but not to each other, I was the result of an affair, my mother tried every trick in the book to have a miscarriage, she played sport, rode horses, all with the desire to stop me from being born, but here I am, alive and kicking and as of now into my sixtieth year of my present incarnation. At the time I was born, I was one of the first new born babies to be placed in a humidicrib, I was told by a person much later in my life, that for my first year I was locked up in the front room and virtually ignored, and since I had only myself, I went into myself and through that experience I became the permanent outsider, the perennial misfit, not only the black sheep of the family but the black sheep with a tinge of rainbow underneath. One of my earliest memories - although I can't prove it - is that I am a soul floating above my mother's body, it is around three to four months into the pregnancy. I believe it coincided with the onset of the quickening, which in the last three to four months while in the womb, the child is expanding, and growing beyond the mere physical limitations of the body.

Fast forward nine years, and I discover that I have a talent for writing. I wrote a work, I destroyed it, I rewrote it word for word, so I destroyed it a second time, I then rewrote again, word for word again. All I know now is that the one copy I had or have is somewhere in New South Wales. Around the age of thirty I found, read and then researched the energy of alchemy. The book was called Alchemy, The Royal Road by Johannes Fabricius. It dealt with alchemy as Jungian and metaphysical, it seemed to work more on the spiritual side and that is how I have always approached it. Roughly ten years later I was talking to a friend from Perth, who said that I had to write a work on Merlin, while I was talking to her the opening piece just roared in from the universe...... Upon a mid winter solstice, on Cornwalls tempestuous shore, a world of ice, snow and sleet. Slush around a pilgrims feet, and a window between worlds opens up once more............ volumes one, two and three have now been completed. It was also around this time that I completed or thought I had completed the alchemy work - having done twenty eight signs, thirteen for the Western zodiac and thirteen for the Chinese zodiac, with Arachne as the extra sign in the Western zodiac, going in between Taurus and Gemini, and with the Unicorn being the thirteenth sign in the Chinese zodiac, at the end to represent the female energy as the opposite to the sign of the Dragon. I was going to add the energy of the I ching to this zodiac but it became too large, so I added it as an addendum to the whole work, plus two other signs, the Dolphin and the Whale. Here I am thinking it is going to follow the female cycle, and honour the female energy, but no, I receive from the universe, the message that there is another twenty six. With this extra twenty six I completed the psychological zodiac, in which I added my own tarot deck, and the spiritual zodiac, thus giving me a fifty two sign zodiac.

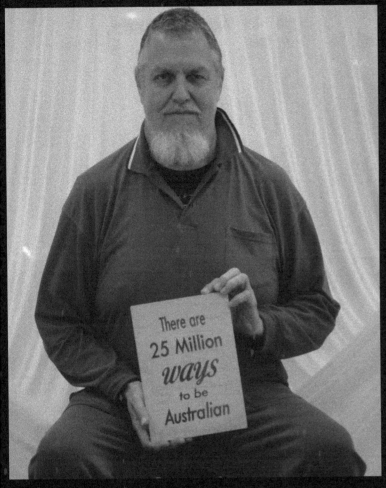

There are
25 Million
ways
to be
Australian

Along with the signs I have incorporated the revised energy of the chakras, thirteen in all, they are in sequence, earth, base, sexual, solar plexus, heart, soul, throat, third eye, crown, solar planetary, universal and gnostic, there are four signs per chakra, each chakra adding another level. In my system it works very simply. If I start with an energy of one and I add a zero for every chakra, thus I end up with a one followed by twelve zeros, that is 1,000,000,000,000, a very potent level of energy if ever there was one. This works on the vertical, moving up the body, there is a fifth zodiac, the transcendental zodiac, this works on the horizontal, it becomes distance, starting at one to the power of one, ending with a distance of 4,196 to the power 4,196. I have since expanded it even further with another sixty five signs over another five zodiacs, thus giving me all up, ten zodiacs, 130 signs,

My philosophy is to me rather simple, I am an eclectic gnostic pagan with Buddhist and anarchistic leanings. I believe that for the human race to fully evolve beyond where we are, we need to get rid of four energies that I believe are holding us back. The first is religion, it is the biggest con of the human race, it is all about power, and manipulation of that power, my god is bigger than your god, my god is better than your god, my god has more power by being a male than your god or goddess. The second is politics and politicians, these are a blight on the whole social, societal and reasonable aspects to the general population, we really don't need them at all, it is and always will be about greed and again manipulation, and if you get someone in politics who follows a religion, that ties it up even more, these people will not think and cannot think or process anything. The third energy we need to remove is nationalism, this is the idea that my country is better or bigger than your country, my country is more important than yours because I provide more of a given resource, I do not have an issue with embracing and even understanding your culture and even acknowledging it, be proud of who you are, but not to the detriment of others. The fourth and last energy needed to be removed is banks and banking, again because greed and manipulation are the natural order of the day.

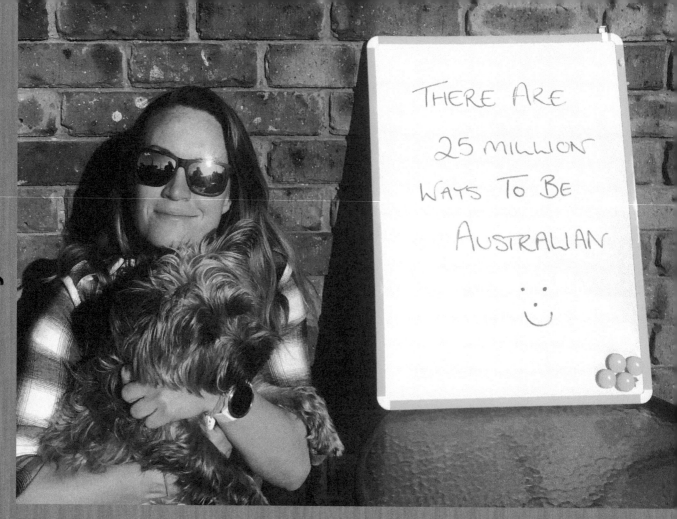

Kirsty Nash

I have two younger friends who often introduce me with "This is Kirsty, the one we were telling you about… the one with the baby". Yes, I have a 2-year-old, but I hope people think of me as something more than 'the one with the baby'. I grew up in England, and came to Australia in 2002, living in Townsville for a few years.

From 2006 to 2008, I worked internationally in Seychelles and then on a school ship in the Caribbean. I returned to Australia in 2009 to work on a dive boat in Ningaloo, and then moved back in Townsville to work at the university as a research assistant, before doing a PhD studying coral reef fish. In 2016 moved to Hobart to the Centre for Marine Socioecology at the University of Tasmania.

Although I am a marine ecologist, I will admit to disliking nature documentaries. I have found that people always expect that I love 'Blue Planet' and other similar shows, but I just can't get into them. Give me a terrible US crime show or any book and I am much happier! But I do love the outdoors; an excuse to get outside to walk, swim in the ocean or really anything active. While it took me a long time to get used to the cold of Tasmania, I do love the outdoor adventures that are on offer here.

Before I had my daughter, I had seen women working in research and academia who seemed to have children with little to no impact on their careers – they worked during maternity leave, travelled to international conferences with babies, and did impactful science while caring for young families. Then my daughter was born and I rapidly found I was struggling to care for my baby. There was no chance could work at the same time! I would wake up in the morning, sleep deprived and in a panic about the day ahead. Soon I was diagnosed with post-natal depression. My husband and I had moved to Tasmania just before having my daughter and we had no support network – it was a lonely and pretty tough time.

I was unbelievably lucky to get amazing help and support from local health services and work colleagues. They gave me the assistance I needed to get back on track both at home and in my gradual return to work. But throughout this time I felt like a failure. Everyone else seemed to cope so much better than me. Why was I struggling? As part of my treatment for post-natal depression I attended a ten week support group at the local parenting centre, where we talked about many things, including the 'myths of motherhood'. It was during this discussion I realised how unrealistic I had been about what motherhood entailed and how I had planned to juggle research and a baby. So, I started talking to other mothers working in academia and I rapidly discovered two things: First, many women who appeared to breeze through maternity leave and the return to work, were hiding a continual struggle to appear in control of their work-life balance. Many regretted working during the early months of their children's lives in an attempt to stay competitive within their academic workplace. Second, all too often, women did not receive the support that I had experienced at work and from health professionals. As a result, they had felt very alone during their struggles.

The post-natal depression support group I attended gave me such an amazing boost and the dedicated health care workers I met inspired me to try and pay forward the help I had received. I applied for a grant to develop an online resource hub to help parents and carers working in academia and research. I didn't get the grant, but in the long run that might have been the kick I needed – I realised I didn't want to give up on my idea and I would try and develop the online hub anyway – it might take a bit more of a balancing act, but I really believed such a resource was needed by so many. There are over 16,000 women working or studying in academia in Australia alone – I knew that many of them would experience the challenges that I and many others had experienced.

aKIDemic Life Ltd is a not-for-profit with a website (www.akidemiclife.com) packed full or advice, interviews and resources to help empower parents and carers working in academia. Much of the content is curated from other places – it is basically a one-stop shop for help so that time-poor carers do not need to trawl through the internet to find the support they need. Users can look up research grants that are aimed at supporting academics with parenting responsibilities or find out about their rights as working parents. There is also a searchable database of peer-reviewed studies on parenting and equity in academia to help people find out the latest information and statistics on being a carer in academic settings. I am the founder and one of the director's of aKIDemic Life. We run on a shoestring budget, trying to ensure the resources we have on the website are up to date and relevant in a changing world. For example, we have added new resources since the outbreak of COVID-19. These are focused on ideas to keep children and family members entertained and mentally stimulated during lockdown, ways to develop an online support network, and help for research students who are struggling to complete their degrees where fieldwork or laboratory work have been stopped or curtailed.

I feel so privileged to have become an Australian. The community and culture have provided my family and I with great opportunities to build a home. One of my favourite things about Australia is everyone's willingness to 'have a go'. It seems like it doesn't matter if you haven't tried something before, there is a feeling that you can join in – this extends from trying a new sport to working in new ways. As a result, we have tried different things and found new interests. I love the outdoor lifestyle – there are so many opportunities to get outside and see amazing nature and scenery.

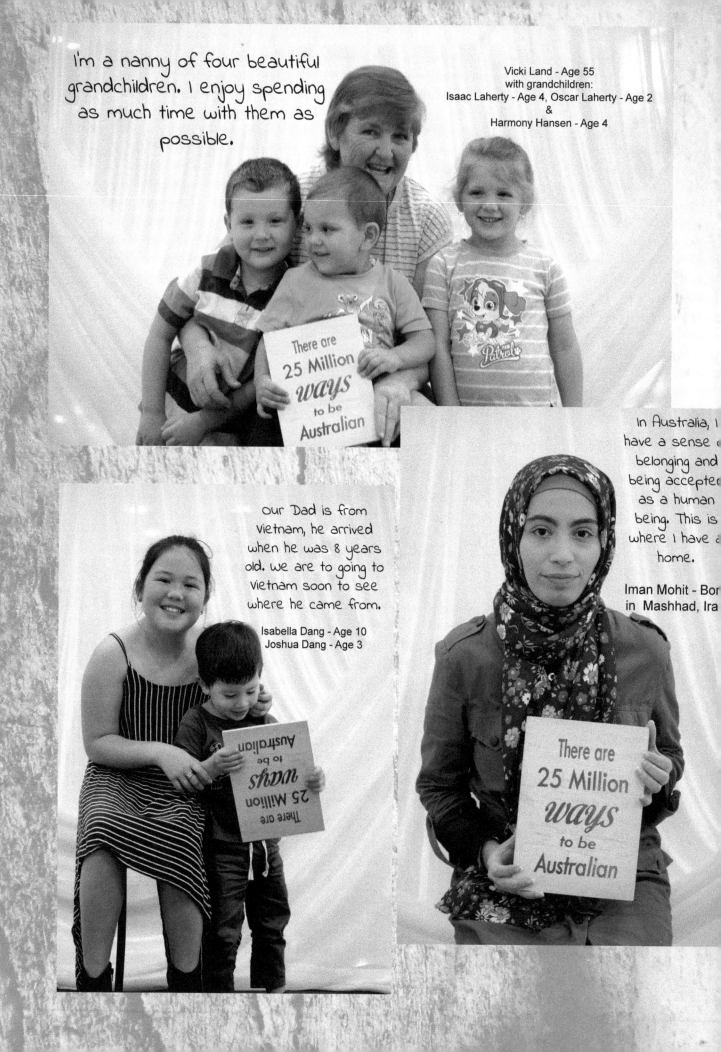

I'm a nanny of four beautiful grandchildren. I enjoy spending as much time with them as possible.

Vicki Land - Age 55
with grandchildren:
Isaac Laherty - Age 4, Oscar Laherty - Age 2
&
Harmony Hansen - Age 4

There are 25 Million *ways* to be Australian

Our Dad is from Vietnam, he arrived when he was 8 years old. We are to going to Vietnam soon to see where he came from.

Isabella Dang - Age 10
Joshua Dang - Age 3

There are 25 Million *ways* to be Australian

In Australia, I have a sense of belonging and being accepted as a human being. This is where I have a home.

Iman Mohit - Born in Mashhad, Iran

There are 25 Million *ways* to be Australian

I'm of Serbian origin. My favorite sport is soccer. I enjoy traveling, learning, building experiences and forming friendships.

Luca Illic - Born in Germany

whanaungatanga me Te Kotahitanga - Brotherhood and oneness. As a Kiwi, I sée Australia as a home away from home.

Kalisi Latusela
Born in Christchurch New Zealand

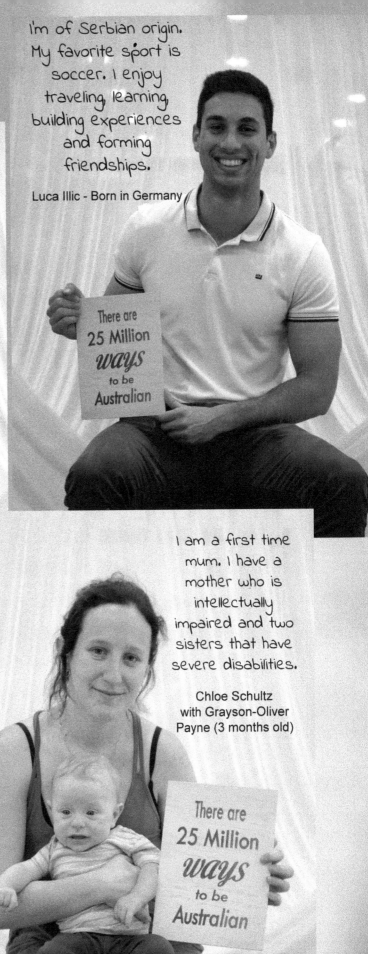

I am a first time mum. I have a mother who is intellectually impaired and two sisters that have severe disabilities.

Chloe Schultz
with Grayson-Oliver
Payne (3 months old)

THERE ARE 25 MILLION
WAYS TO BE AUSTRALIAN

Michael Connolly
(Mundagutta Kulliwari)

I am a Aboriginal Artist. I descended from the Kullilli People on my father's side and Muruwarri People on my mother's side.

My business started with selling a few didgeridoos on a mat at a local market and it grew from there. As I started to get into the Aboriginal Art business I was finding that there was so much more to Art. It was the culture behind the art, he stories, the music and dance. It was about our People and I felt that I needed to do more than just art. I had to tell the story, the truth that is both good and bad and this continues even 24 years down the track. So, we are now an Aboriginal Art Retail Shop, Art Gallery and Cultural Education Centre - the one stop cultural shop.

I am a First Australian - my People have been here since the First Time. In fact I have had my DNA done and it was determined that my DNA M42A shows that it is found nowhere else in the World and is over 50,000 years old, but I have always known that

My message is - RESPECT - have respect for yourself - have respect for your family and more importantly have respect for everyone else especially those who are trying to look out for your health and well-being.

Unfortunately, Life as we knew it will never return - Mother Nature has been severely injured but Father Time is giving us this opportunity to stop and reflect. We have been forced into isolation in 2020 so we can stop and reconnect with ourselves - our family and our environment. We have been so focused on War and killing people that we have taken the foot off the pedal when it comes to ourselves and our well-being and the health of humanity. Life starts at the grass roots and we the people are the grass roots of humanity.

There are
25 Million
ways
to be
Australi

Peter Csollany

My father was 65 when I was born. He lived to be 97, I don't think I'll live as long as him. Six years ago I had a stroke and lost the use of the right side of my body. I had to learn how to walk and talk again. I learned to walk again with 7 other stroke victims. Today only 2 of them can walk. I want to inspire other stroke victims.

I don't have a phone or email because I think it would be too much of a distraction to my recovery.

I lost 55kg in the past year because i want to live as long as my father and I wan to inspire my son, even though I'm not allowed to see him and I don't have custody. I want him to know anything is possible. Next, I want to learn how to rock climb.

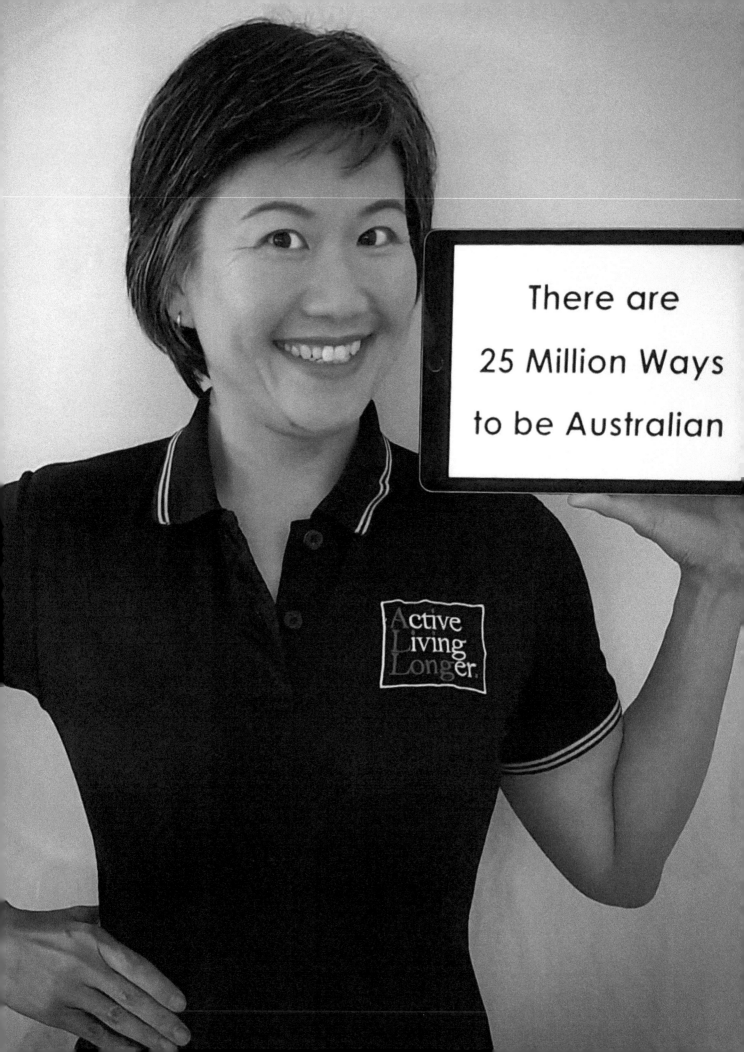

Eevon Stott

I am a practicing accredited exercise scientist and CEO of not-for-profit, Active Living Longer Inc and a adjunct research fellow in the Charles Sturt University School of Exercise Science, Sport and Health.

I took up flying as a hobby because my doctoral research was becoming too consuming and I needed a distraction. It actually became a little too distracting because that is how I met my husband! Once I earned my Pilots License, I started to assist with the theoretical components of learning to fly and we hosted small workshops with one on one mentoring.

We do miss the face-to-face contact but COVID-19 has also enabled us to trial online service delivery, which went really well. In fact, we are now planning for online services to become the main mode of services rather than face-to-face. Because the ultimate objective of Active Living Longer is to develop competency and increase confidence in people becoming and staying active, we are able to do so through online educational interventions.

Australia has afforded me opportunities that have changed my life. Interestingly, the two examples I have are both to do with education. Firstly, when I moved from Singapore to Brisbane to complete my undergraduate studies with The University of Queensland, the academics there sparked my love of learning which has stayed with me since. After obtaining my degree, I returned to Singapore only to pack my bags again 7 years later for Bathurst NSW. Once again, education – through the process of doctoral studies – became a tool that shaped the way I learned to think. These are life long skills that I continue to use daily.

Isolation means different things for everyone. At the risk of sounding that it was all smooth sailing, the best thing that came out of isolation was being able to use the time for introspection, creating new routines to improve my daily life, and the opportunity to pivot our service delivery. In short, life-lemon-lemonade!

Michael Corry

I have lots of stories, I don't know where to start. I haven't travelled outside of Australia but I wish to go to the opal mines of South Australia. My father was a cook for a coach line and would show me photos of the underground houses and hotels and he always wanted to return. I want to see it but my financial situation restricts me from going.

I'm an avid theatre buff and my dream role would be playing a lead role as Frankfurter in the Rocky Horror Picture Show. I'm a baritone so I'm mainly a chorus member but I have played many different roles on stage.

I went to university on three different occasions, in 1983 I studied Environmental Sciences. After that I studied physics and maths and only last year I finished my second year in teaching. I hope to get back into teaching maths, physics and chemistry to high school students once I gets my finances under control by getting a job.

Kaye Heard

I came to Australia in 1941, I was 11 years old. It was me, my parents and my 4 brothers. We lived in Kensington, England and my father had decided to come to Australia to before our house got bombed out in the blitz. Initially, I wasn't going to come, my parents were going to leave me with a friend because I didn't want to leave my friends.

We arrived in Sydney after a 6-week journey on a ship. They sent us to a migrant camp in Home Glen . It had a communal toilet and we ate in a cafeteria style kitchen. The camp in Home Glen was originally a rubbish dump and then they filled it in and built military style tin huts and used it as a migrant camp.

I hated it so much that I planned to stow away on a ship and go back to England. I even went so far as to pack a suitcase and go back to the train station, where I caught a train to go to the shipyard. I only got one station away and then got hungry and turned around and went back to the camp to eat.

At the time I came to Australia, you had to put in a request to come and you had to have a job lined up before you got here, which my father did. He managed a farm. You had to hold that job for 12 months or get sent back.

One of the houses we lived in on the farm had a house in front of it that had a dirt floor and the lady who lived there cooked over a fire in the middle of the house.

I went a school with 20 other students in the entire school. I would have to walk 8 miles to the bus stop to catch a bus to school and it would be dark. So I chose to get a job instead at a telephone exchange where I earned 8 Schillings a month plus my keep.

I later married a military man and went wherever he was posted. I lived in Malaysia once. I worked as a nurse after I got married. I worked in Sydney, Melbourne, at the Mater and for Tri-Care. It took me 8 years to become and Australian Citizen and one of my brothers still isn't an Australia Citizen.

We have five kids together and my family numbers at 33 including kids, grandkids and great grandkids and they are all over Australia. My phone rings hot every day of the week with calls from my family all calling to see how nanny is doing. From two people, we now have 33!

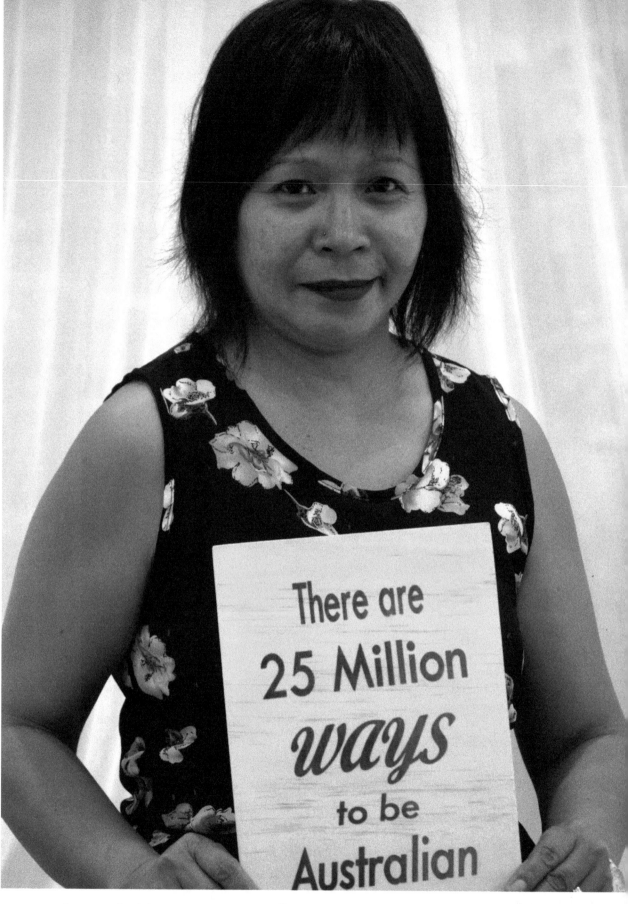

Rosalina Rowlands

I was born in the Philippines. I came to Australia in 2001 when I married Australian man. I have
kids, a boy and a girl who are 18 and 19 years old. I have greater freedom of choice when it co
to medical in Australia. I love the weather in Australia because it is very similar to the Philippi
love being a mum.

I came to Australia for freedom of choice, back home I couldn't afford to stay home with my children. I loves New Zealand, it's a beautiful place but it was difficult to make ends meet At least here I can go to the shops and buy new outfits for my kids. They don't always have to have hand me downs. Right now, we are going home to make toffee apples.

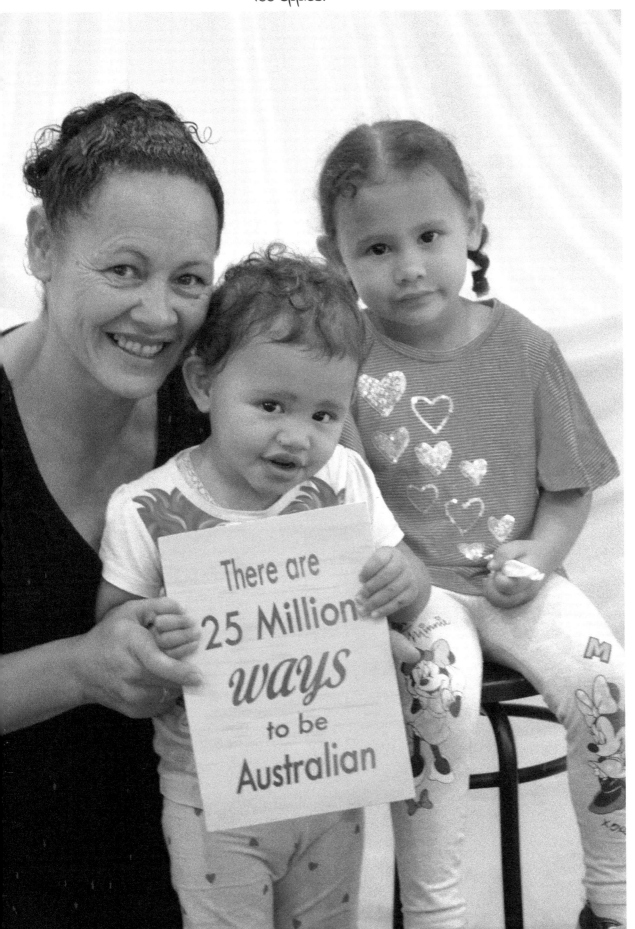

Rangi Lucas with Kara and Tiana

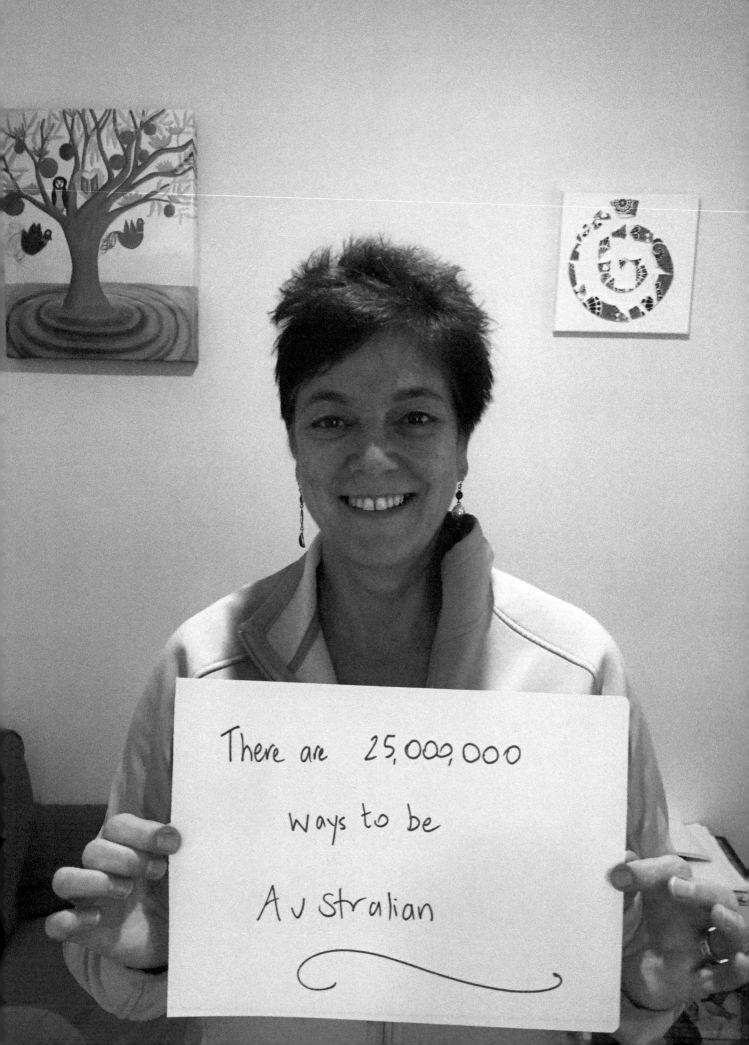

Pip Brennan

I wa born and bred in Perth, WA, the youngest of 6 children, fifth girl. My parents named me after my deceased uncle Philip, plus also because Great Expectations was my Dad's favourite novel. Besides, fifth girl, they were running out of inspiration for women's names. I have a Bachelor of Arts majoring in English and Languages. Qualified for nothing, I have been a museum professional, an English Language teacher, and for the last 20 years, a non-profit professional. I have also lived in London and in Thessaloniki, Greece. I now live in the Southern suburbs of Perth with my husband and adult daughter. She lives in the granny flat out the back.

I was the $57 bride. $25 frock from Good Sammies with some alterations done for $30, plus the perfect $2 shoes from Vinnies. Viola, $57 bride. I married my true love late in life, when I was 43 and he was 52 – my daughter was 10. I met him when I bought the house opposite him – we live in his house and rent mine out.

I really truly believe in the importance the lived experience voice, asking people who use services, what those services should look like. Also what they need to live a better life, which may not be a service delivered by a clinician, it may be peer support for example. I also think it is really important to look for the gap between policy and reality, focus on implementation, where the work really is. A policy is like a diet plan – it's not lost weight! Much hard work and reflection is required for lost weight.

I write on the weekend. Being an author is what I truly want to do with my life, but not making my art pay the bills is my current situation – so I am an activist during the week, novelist on the weekend.

I run the Health Consumers Council in WA. It is a consumer advocacy agency, a small, independent, not profit organisation dedicated to ensuring the lived experience voice is at the decision-making table. Plus we want people to be able to make informed choices about their healthcare, difficult when much of the information you need to make a decision is either not publicly available, not available anywhere in a coherent form, or buried under a million links and PDFs on websites. Every state and territory (with the exception of the Northern Territory) has one. We are the only one that offers individual advocacy as well, to help people when they're stuck in the system.

I lived abroad for 10 years, my daughter is half-Greek (not my half) and I've been back for two decades. I have re-evaluated Australia many times. I absolutely love the Australian country-side, it is unique. What will really transform Australia though is when we truly celebrate and appreciate our First Nations people.

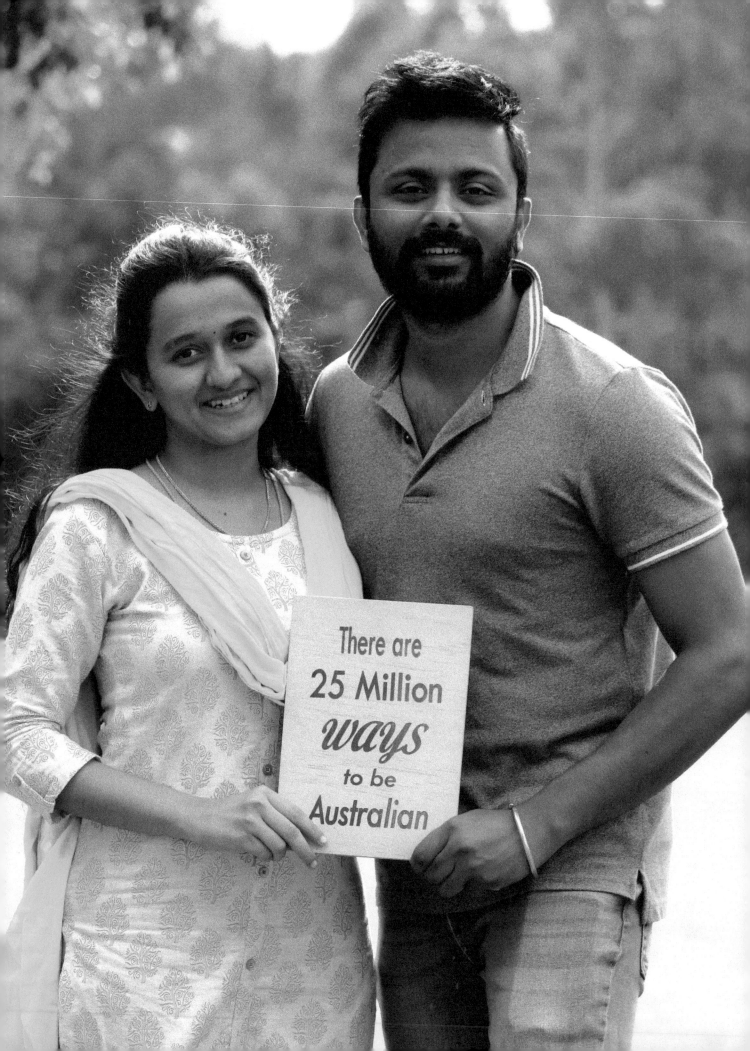

Vignesh Sundaram
(pictured with his wife, Siraranjani)

On May 31, 2017 in Sydney at 8.50pm I landed in Australia. I hoped that after arriving here, my life would change and everything would fall in place for me. But actually nothing fell in place.

The place where I was staying was my relative's place. After two days they said, they were not comfortable with me and I have to leave their house in a week. I didn't know anyone in Australia.

I only had $2500 when I came here. The next week after that, I shifted to a new place and I had to pay rent of $350 per week. I went to all the main streets of Sydney and applied for all the jobs. I was ready to do cleaning, dish washing or any jobs to survive. After 3 weeks I got a job and settled in Australia. Now I am in a good position. So, I faced a lot of struggles but my self belief brought me here.

I am now an Engineer.

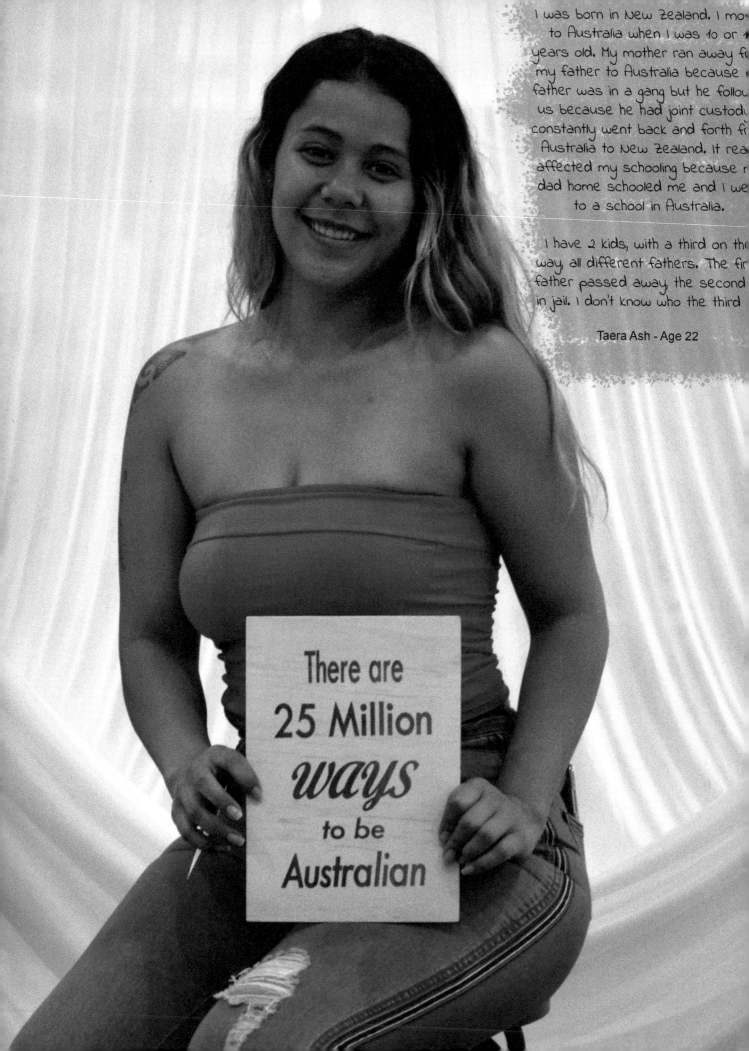

I was born in New Zealand. I mo___
to Australia when I was 10 or ___
years old. My mother ran away f___
my father to Australia because ___
father was in a gang but he follo___
us because he had joint custod___
constantly went back and forth f___
Australia to New Zealand. It rea___
affected my schooling because ___
dad home schooled me and I we___
to a school in Australia.

I have 2 kids, with a third on the___
way all different fathers. The fir___
father passed away the second ___
in jail. I don't know who the third___

Taera Ash - Age 22

There are
25 Million
ways
to be
Australian

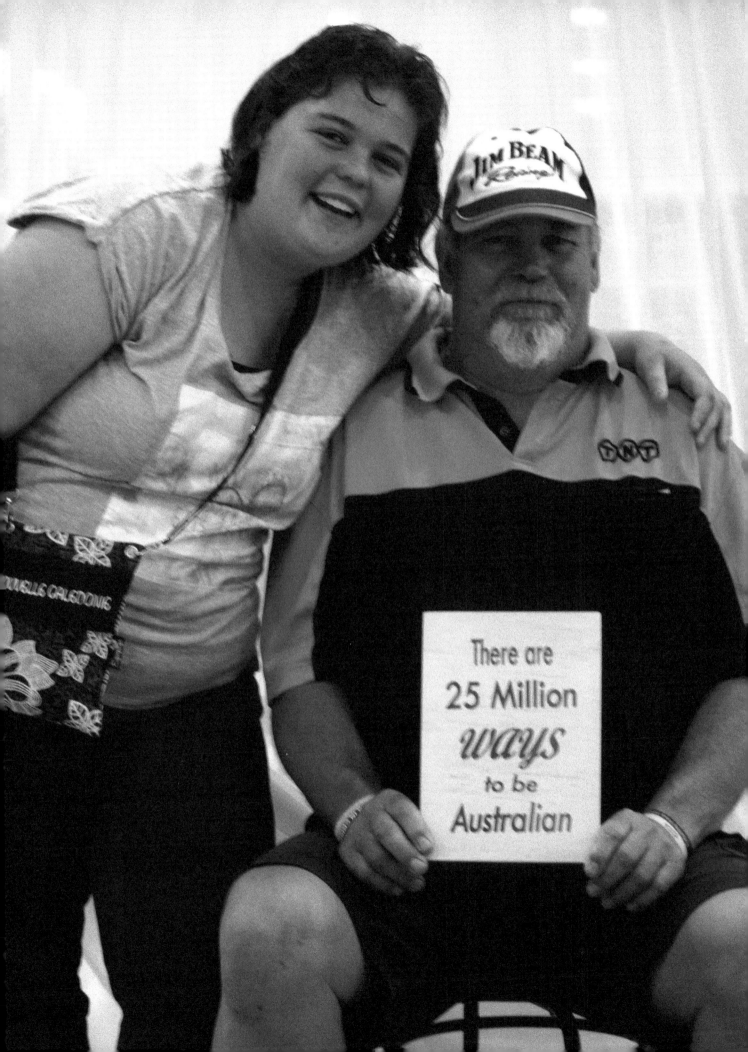

There are
25 Million
ways
to be
Australian

Maddison Ernst and Wyatt

I'm 18 years old and I'm from Brisbane Australia. I would like to share my story with you. Because I want to have my voice heard and help others. When I was a child I was in foster care, bad things happened to me in foster care. It affected my life. I suffer from depression and ADHD. I also have a learning disability it effects my learning process. I want all kids and adults that were abused in foster care to get peace and closure. I was also bullied in school for my looks. It affected my self-esteem and I started self harming.

I cried everyday because I didn't wanna go to school! The teachers didn't do anything to stop the bullying. I got detention for no reason at all. I got pushed over by a boy which made my arm sore it still hurts to this day!

My goal is to become a nurse because I'm caring and I have a supportive personality. I want to inspire everyone to stand up and have their say. I want kids to have their say as well so kids can have peaceful life's and bullying to stop all together. Remember to keep smiling and seek help if needed don't let anyone bully you and tell someone immediately if your depressed or not coping at school.

Wayne Ernst

I'm an Activist. I was brought up on a farm. I worked hard his whole life and I believe working hard will solve many of the problems we have today. No matter what culture we are, we are all one, we all bleed red. I don't just want to fight for myself or my daughter but I also want to fight for all the downtrodden in the world.

I went to Family Court, Children's Court, The Children's Tribunal and back to Family Court several times to fight for custody of my daughter Maddison. Being a father means everything to me because I never thought I would have kids of my own.

My ideal world would be one where people fight for each other and stand up for what is right. I would love to go back to the days when people greeted each other with a handshake and looked each other in the eye instead of at phone screens. When social media didn't dominate the world. So people could have actual conversations. I wish more people were listening to the everyday person rather than mainstream media.

I have a dog, an American Staffie named Ollie. I like to dress him up in costumes.

What do you want
to be when you
grow up?

"A Superhero
and I'll say 'Hot
sauce, on you
bad guys!'"

- Hemaya Palmer,
age 3

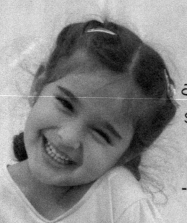

There are
25 Million
ways
to be
Australian

I'm thankful for living
Australia because
peaceful and is
beautiful country th
everyone would love
live in. But I don't like
I'm far away from
family and Austral
doesn't really allow s
countries to visit

-Rawan Al Haide

There are
25 Million
ways
to be
Australian

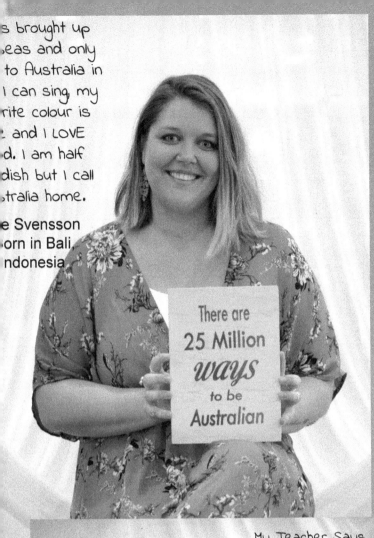

...s brought up
...eas and only
... to Australia in
... I can sing, my
...rite colour is
... and I LOVE
...d. I am half
...dish but I call
...tralia home.

... Svensson
...orn in Bali,
...ndonesia

There are
25 Million
ways
to be
Australian

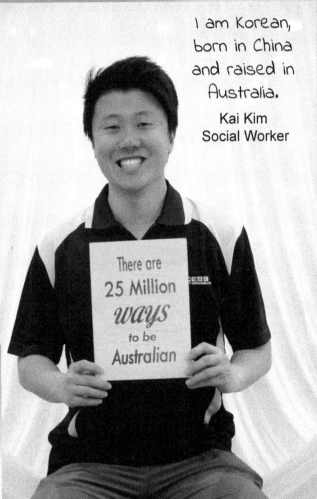

I am Korean,
born in China
and raised in
Australia.

Kai Kim
Social Worker

There are
25 Million
ways
to be
Australian

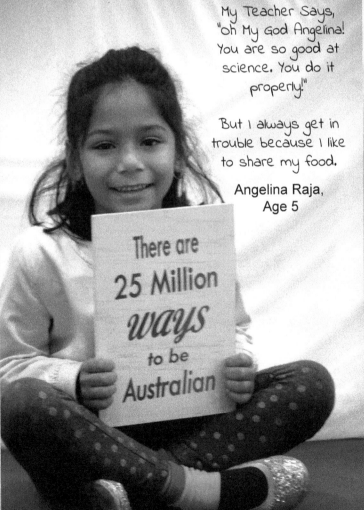

My Teacher Says,
"oh My God Angelina!
You are so good at
science. You do it
properly!"

But I always get in
trouble because I like
to share my food.

Angelina Raja,
Age 5

There are
25 Million
ways
to be
Australian

Michelle McGarvey

I am a Mum of two, business owner, JP, social media and wine enthusiast! I was born in New Zealand, lived in Italy and the UK before moving to Australia in 2009.

I started my business in 2016 after my second child was born. The thought of spending 2 -3 hours commuting to/from the city was unbearable, and a home business would allow me to spend more time with my children, contribute to the household income, and keep my skills up-to-date…but it turned into so much more!

When a chance meeting with another local business owner lead to attending my first networking meeting later that week, I was thrown into a world where business suddenly meant so much more than being able to work from home – it was about building a community and connecting with others…and now, I find that is what drives me – helping others to succeed.

There are two parts to my business! I first started out as a Virtual Assistant – that is, a freelance administrator supporting local business owners – and this could be anything from building simple websites to managing their social media management, planning events for them or undertaking research on their behalf.

Then with my passion for community, I decided to launch the second part of my business - the Redlands Business Directory, which is a resource focused solely on businesses on the Redlands Coast which allowed our community to connect with local business owners.

Being Australian means everything to me!

My husband and I were in London on our O.E. just as the GFC hit. After seeing people walking down the streets in London with all their office belongings in a box, we had, had enough. We packed our bags moved to Brisbane, worked hard and became Australian citizens.

We own our own home, are raising a young family and are both successful business owners.

For now, life is good and we are grateful for the opportunities we have.

Interestingly, my great-grandparents were actually farmers in Queensland but immigrated to New Zealand some time ago, so in some ways, it like coming 'home'.

with gratitude

We are grateful to everyone who participated in this project so far.

We would not have been able to get this project off the ground without the support and funding we received from the following

Supported by
Cr Jon Raven
Division 5
LOGAN CITY COUNCIL

Logan **Central** *plaza*

is
STYLE

KAIK
DESIGN

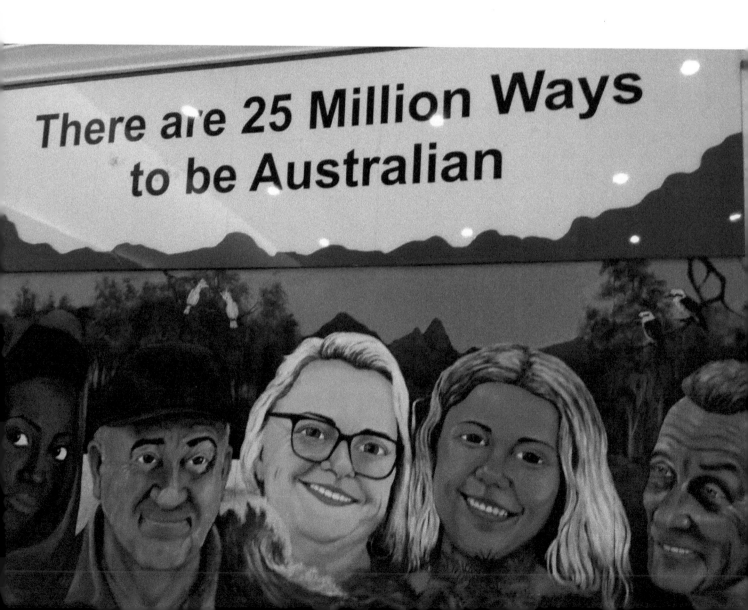

Lightning Source UK Ltd.
Milton Keynes UK
UKHW051052170521
383849UK00005B/33

9 780645 152517